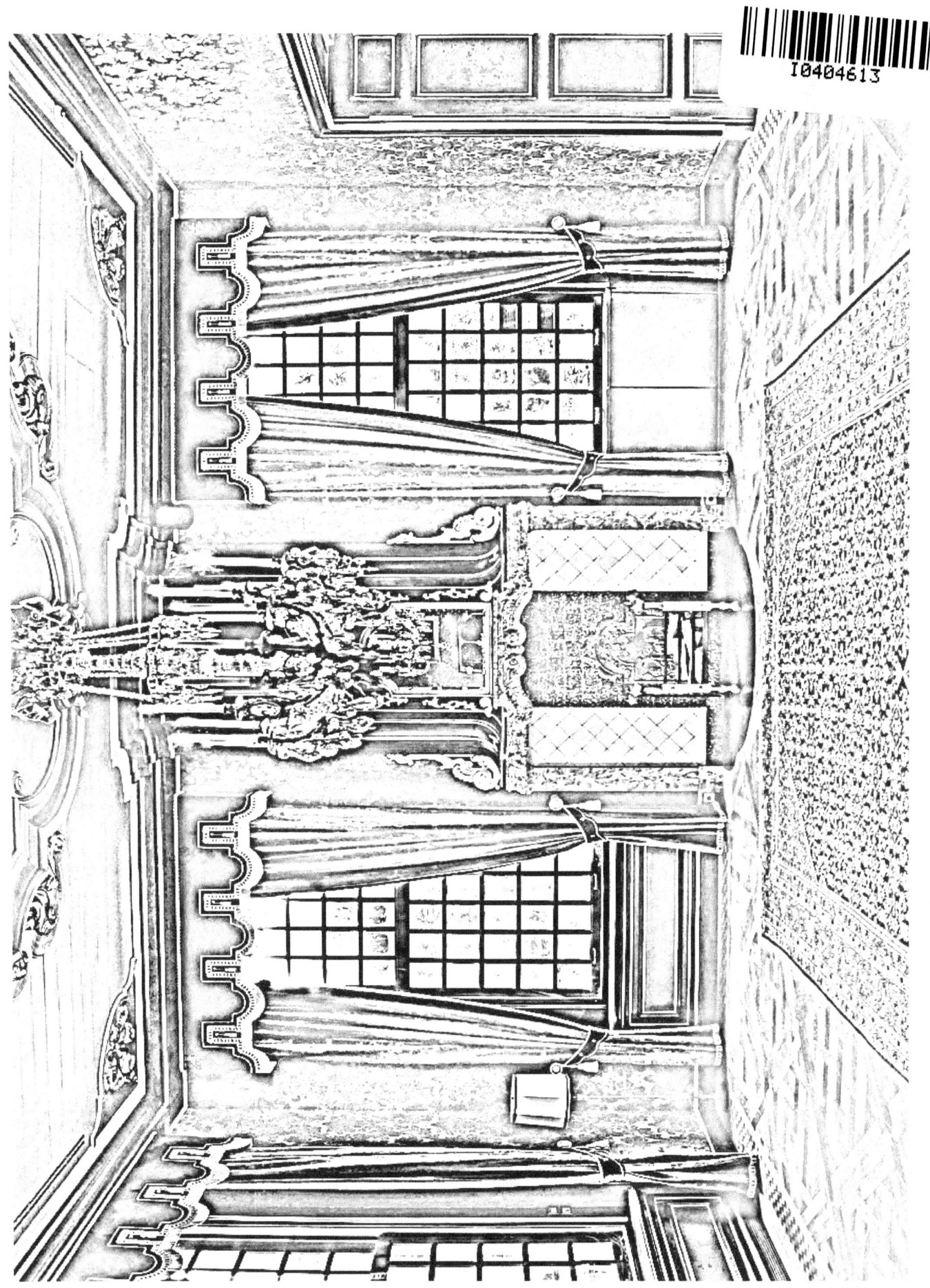

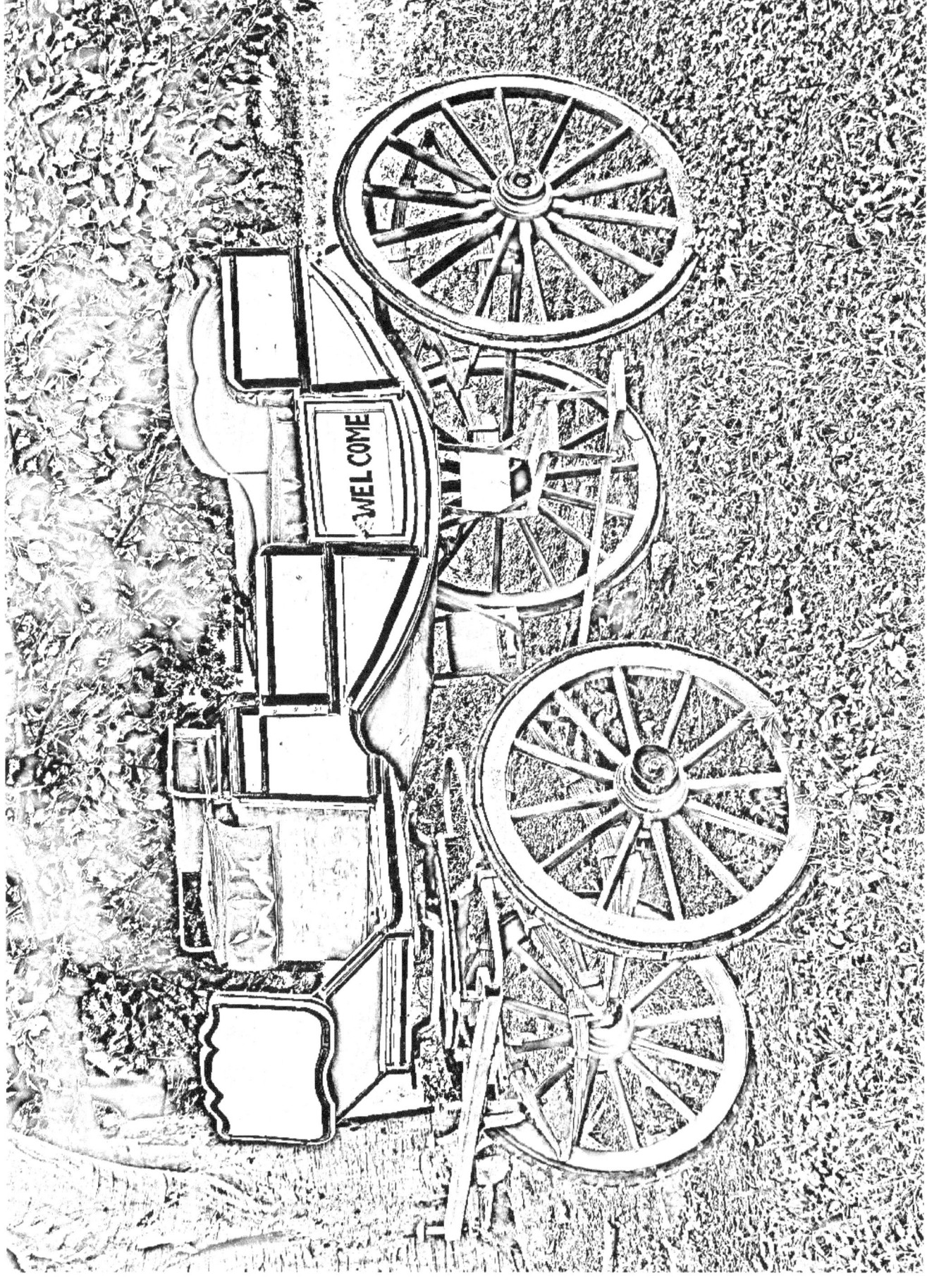

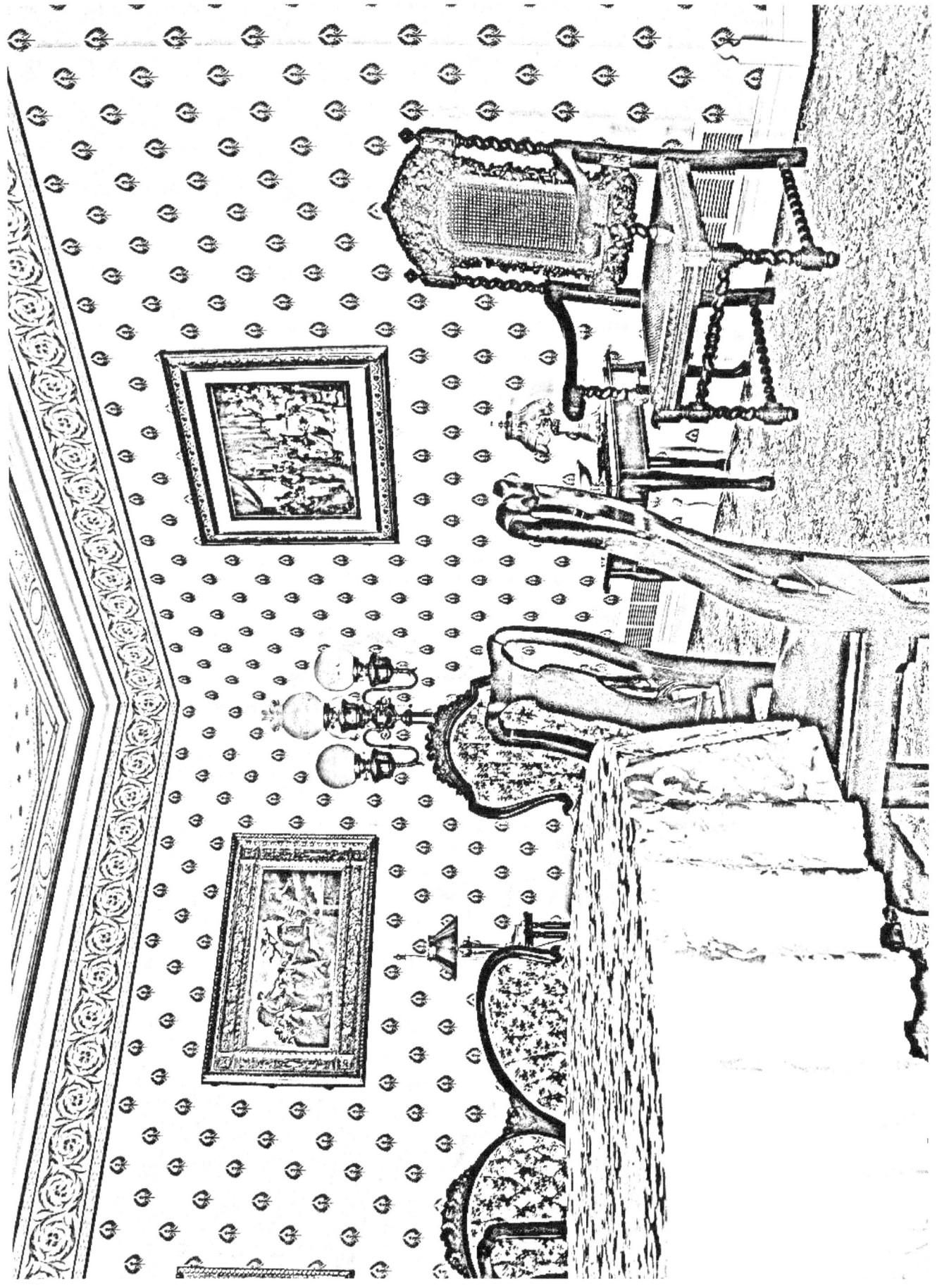

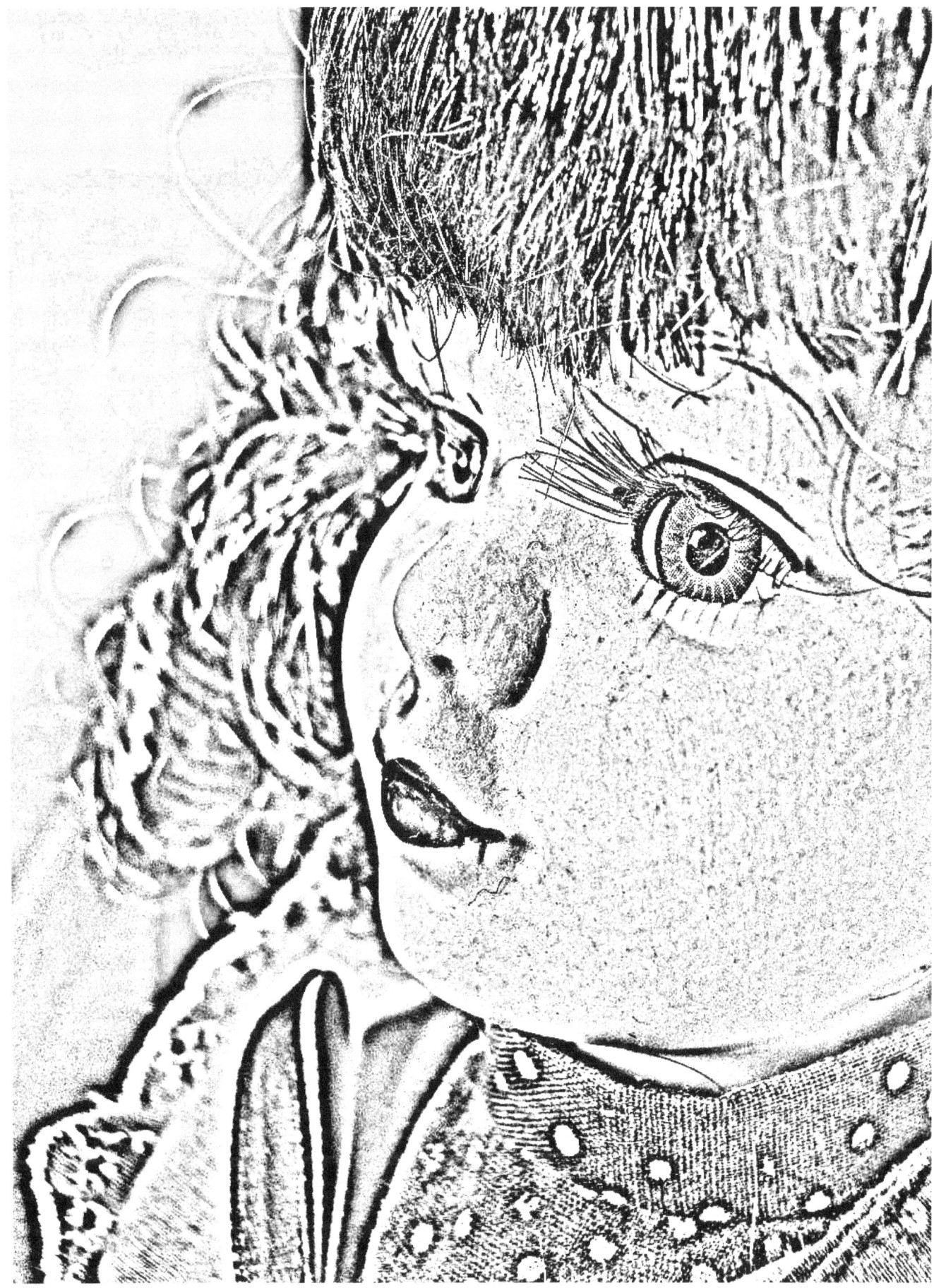

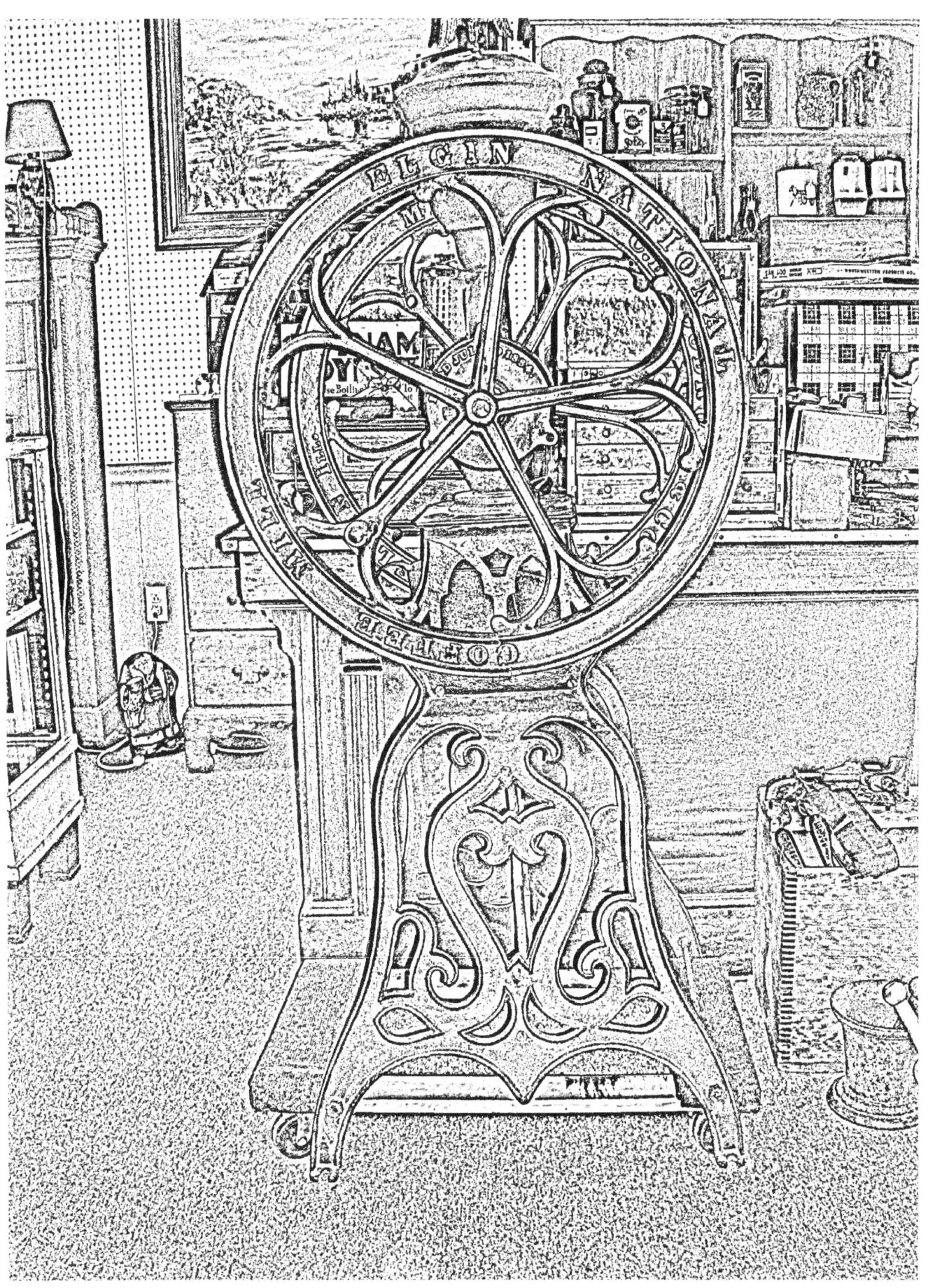

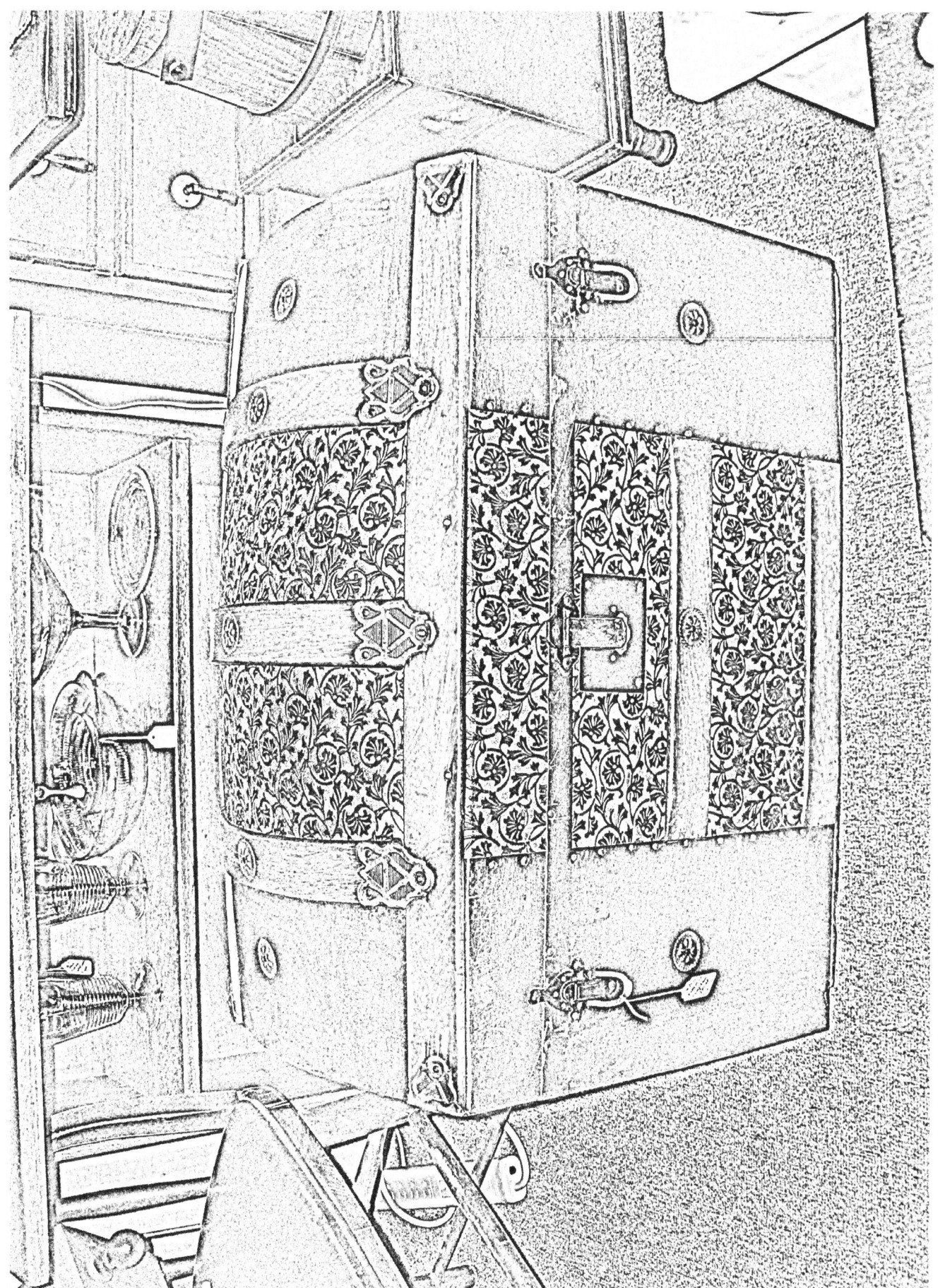

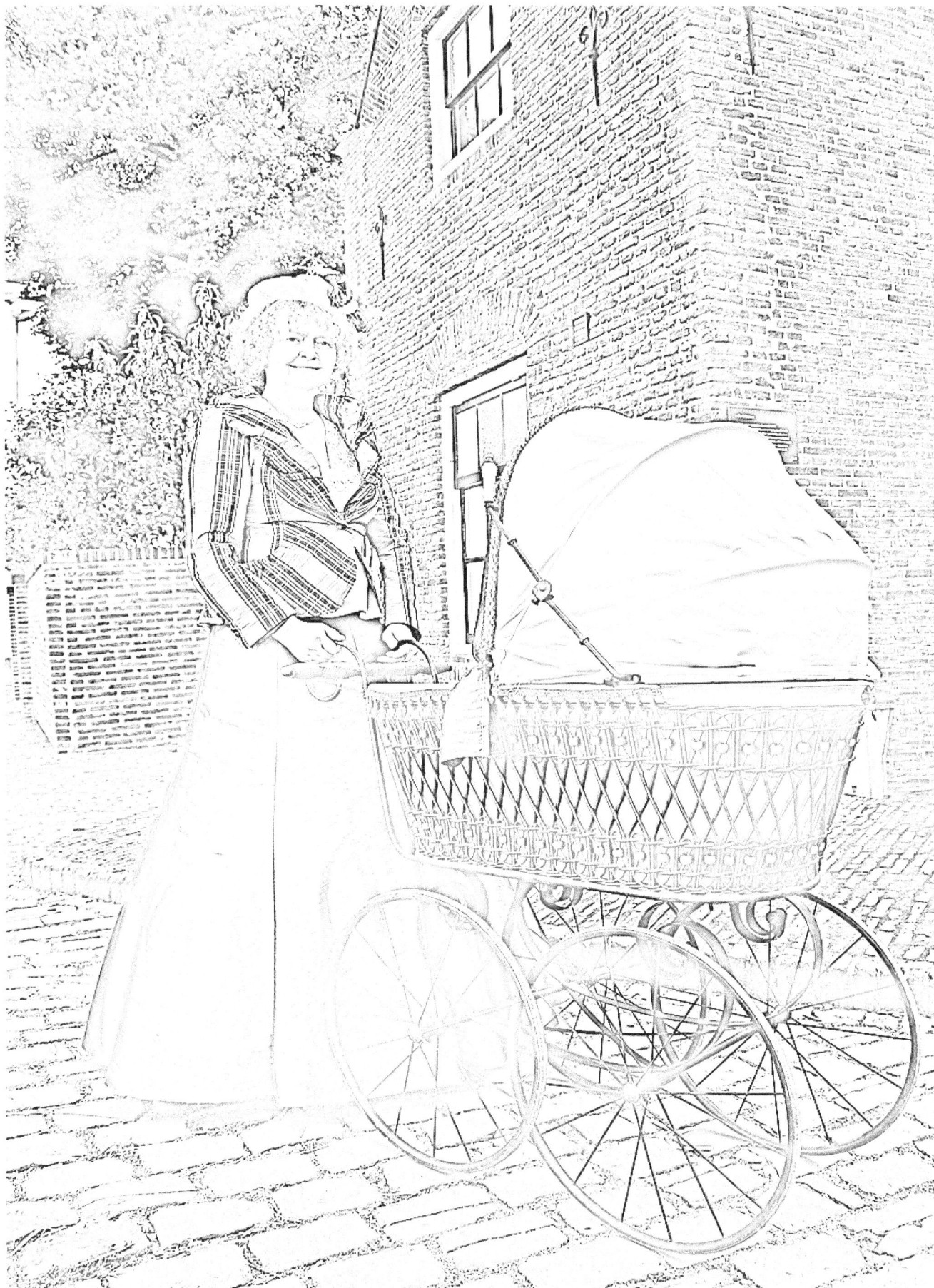

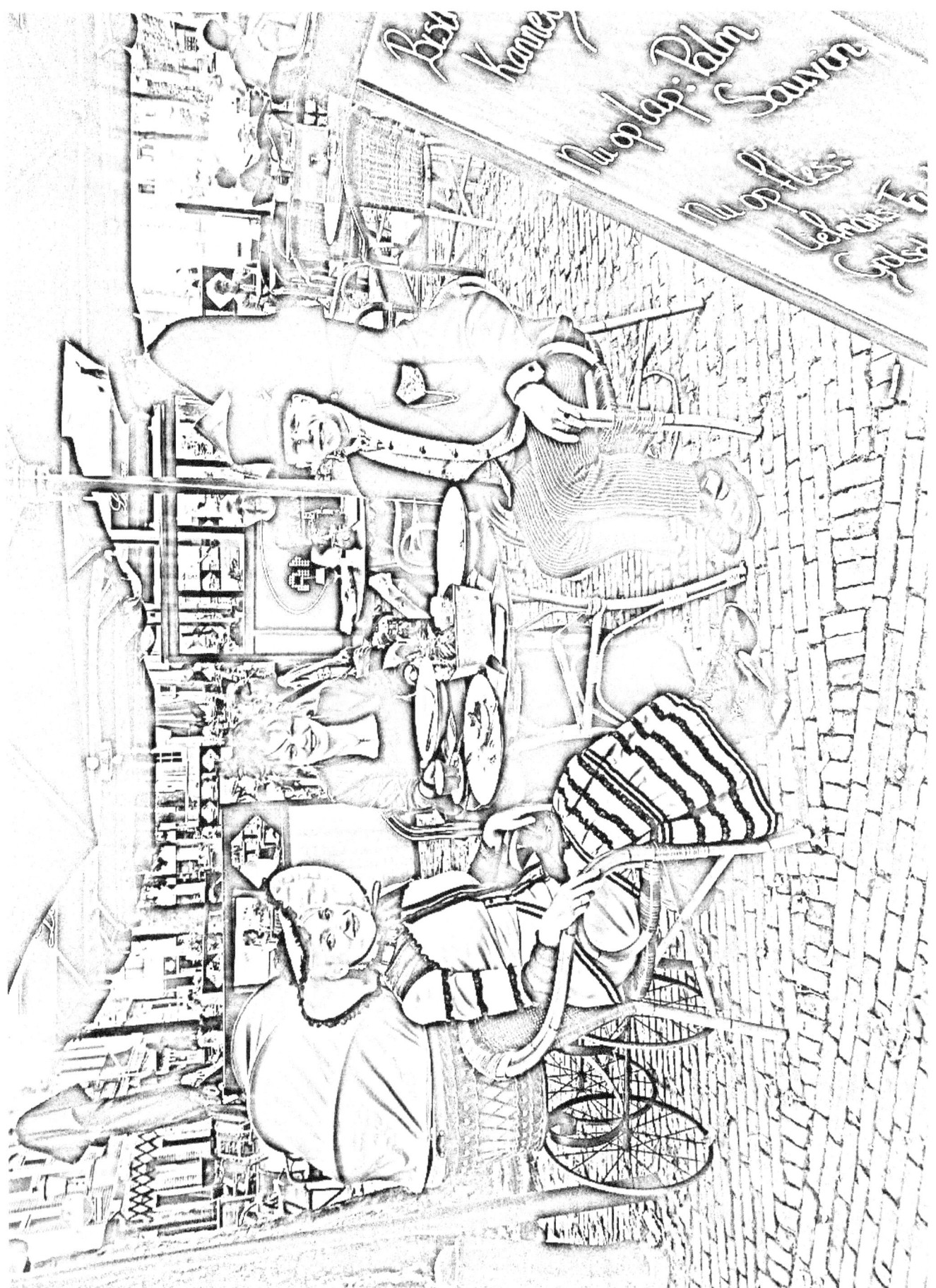

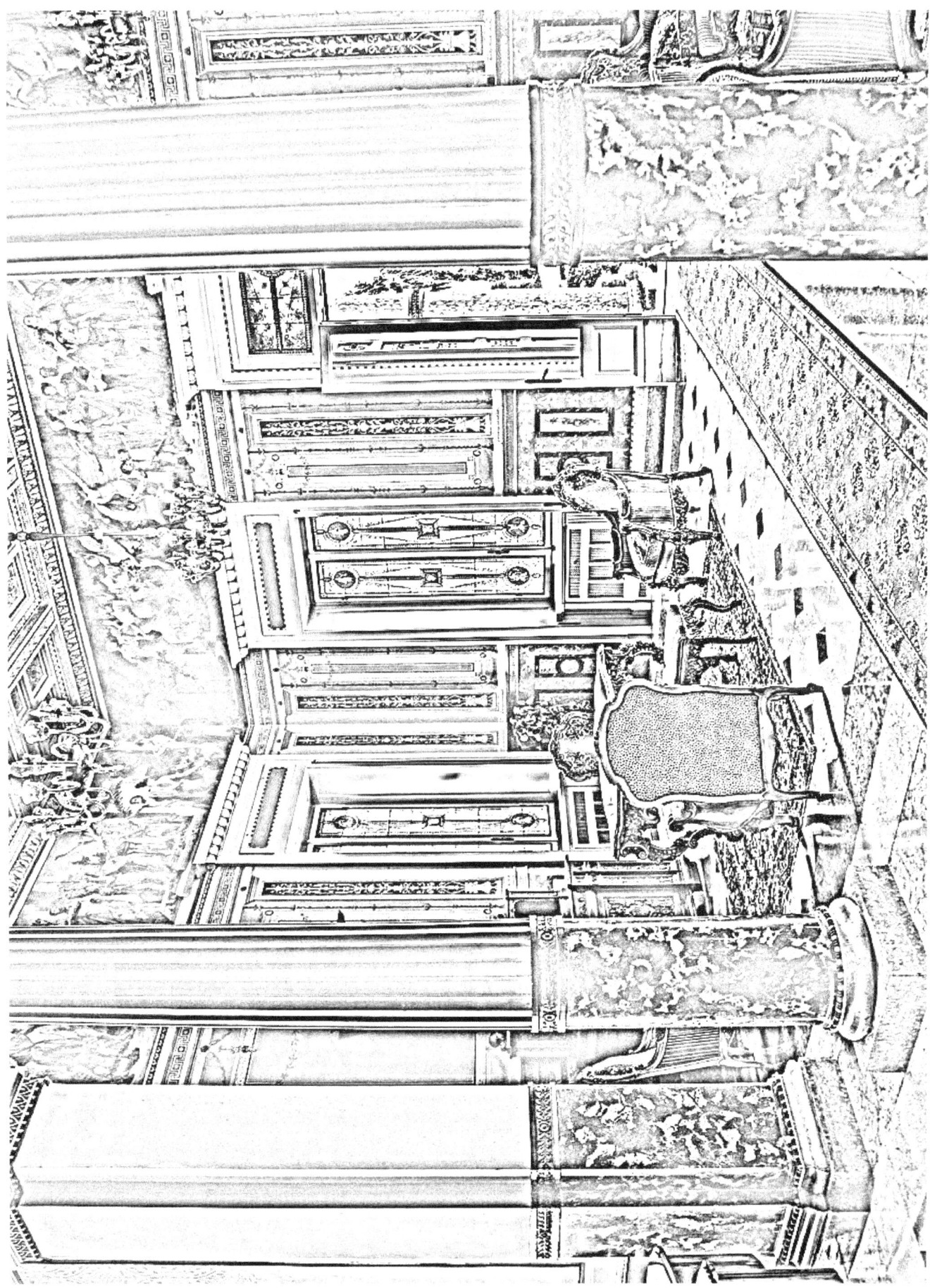

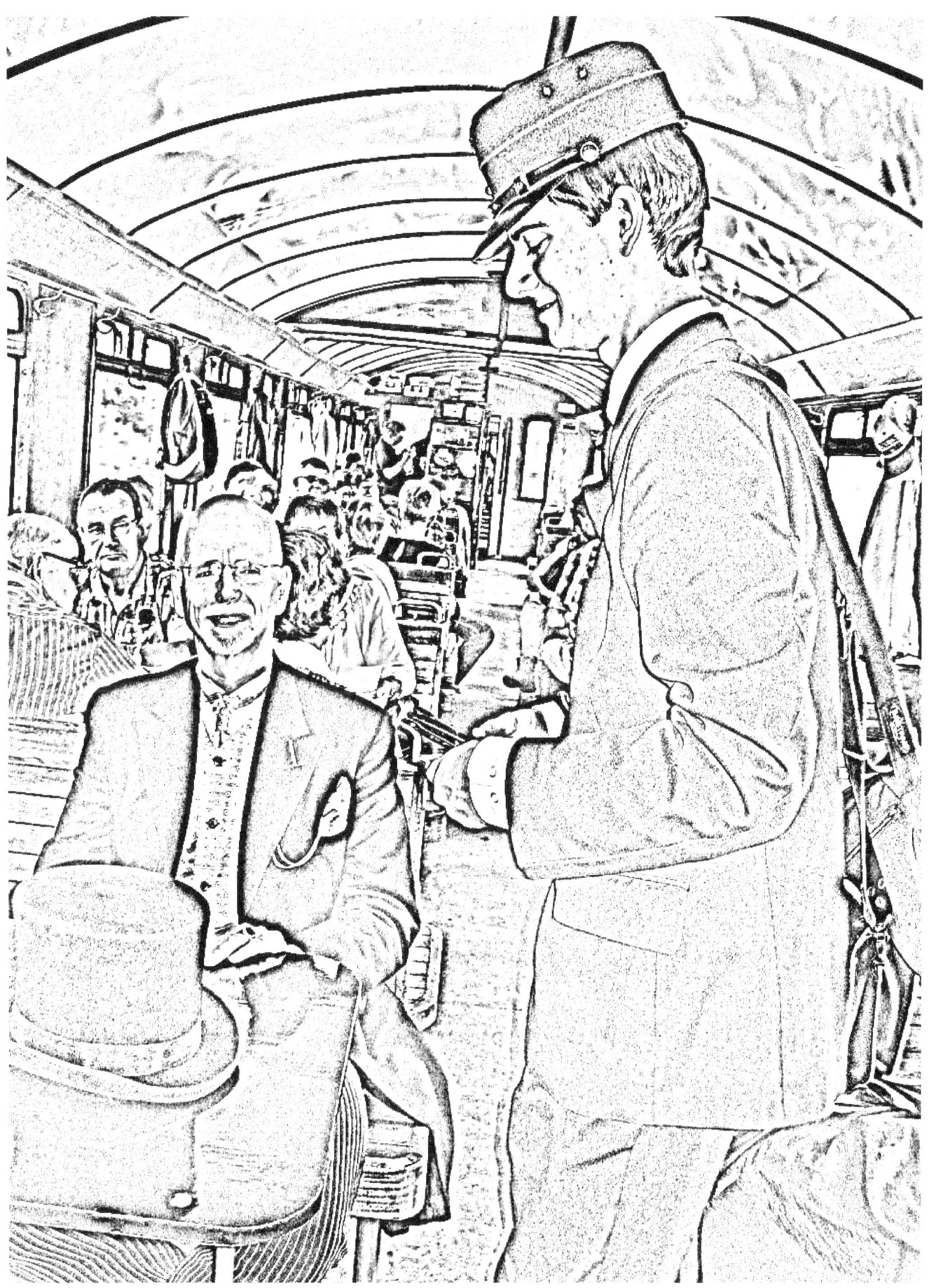

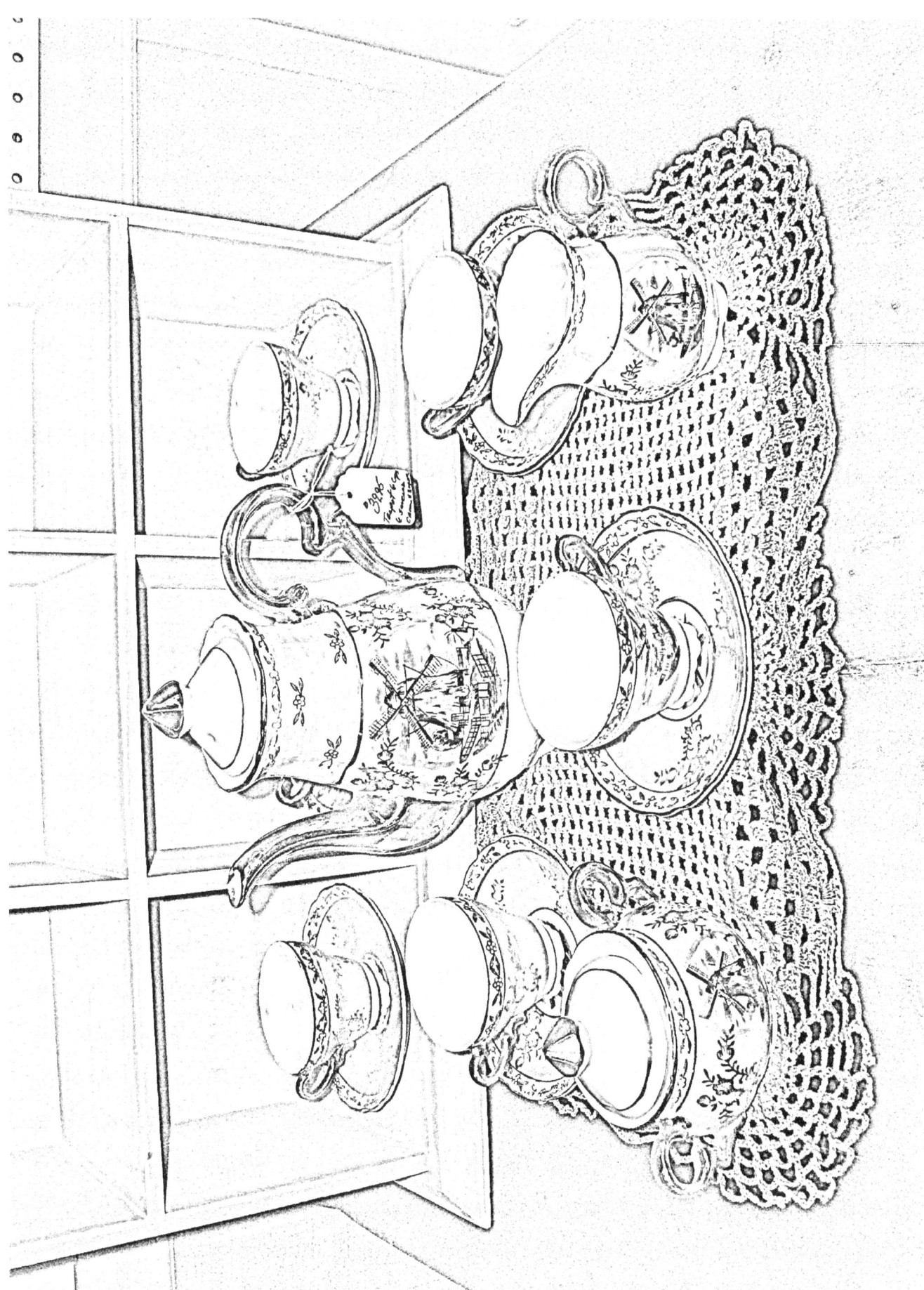

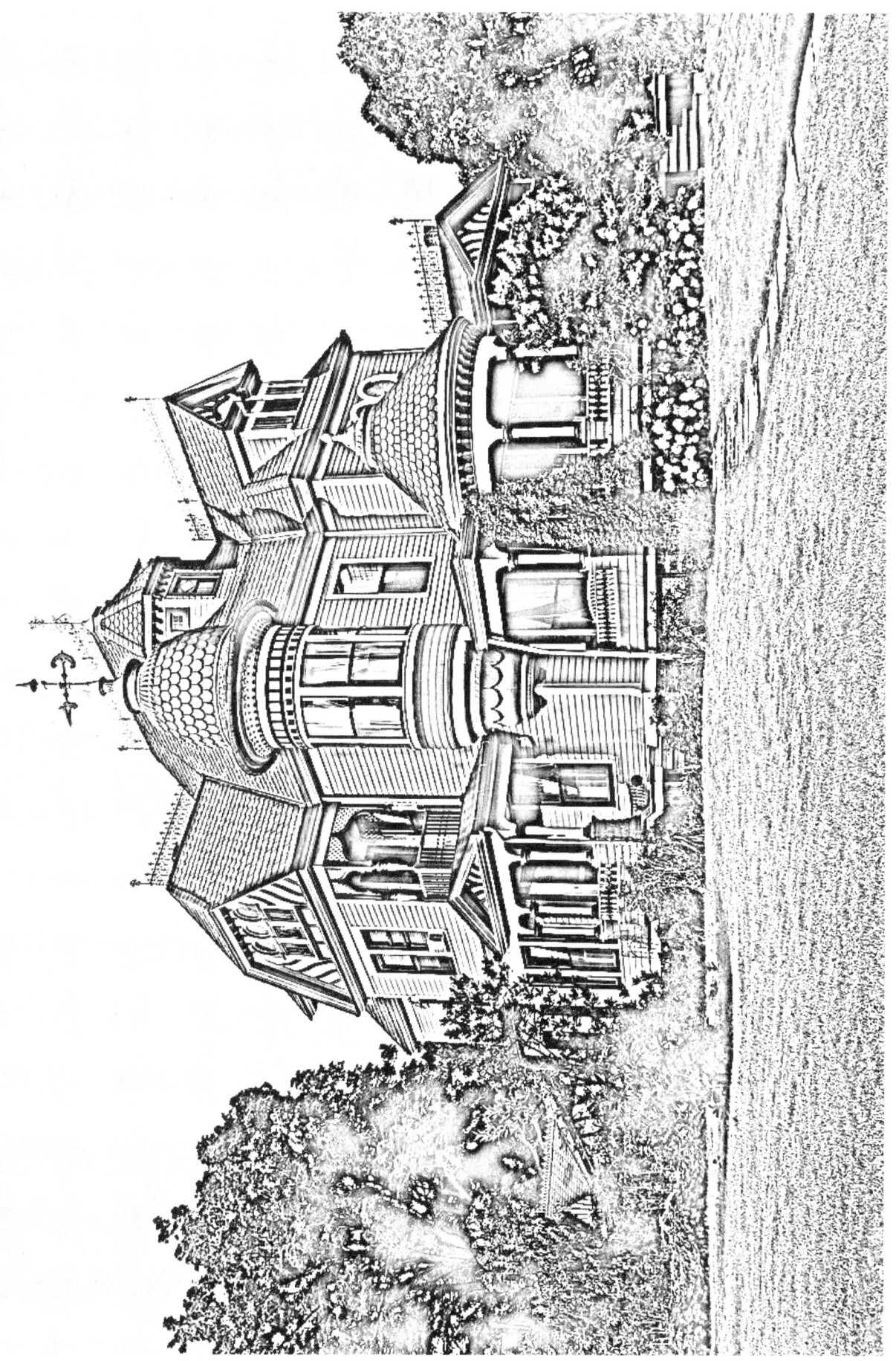

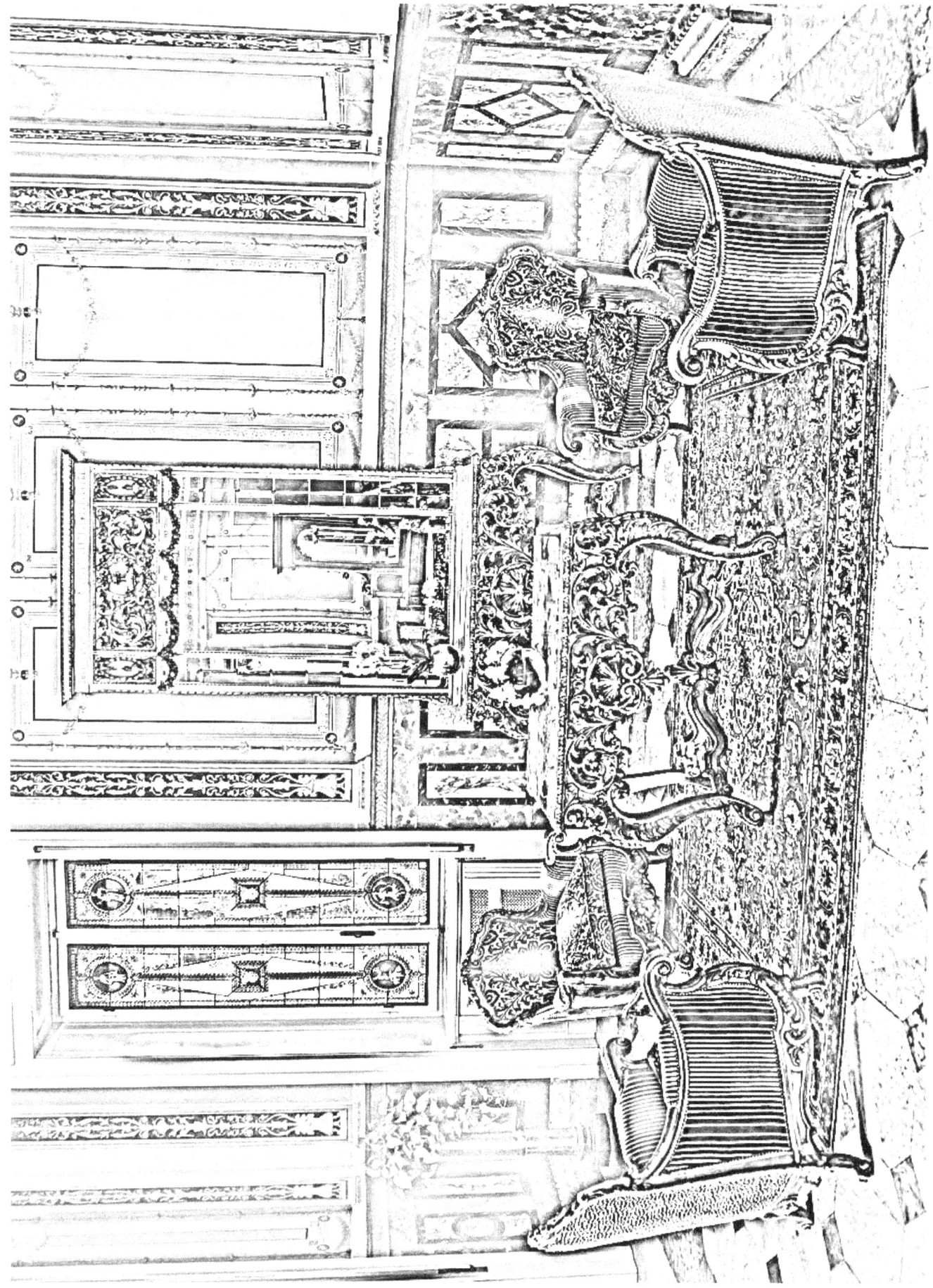

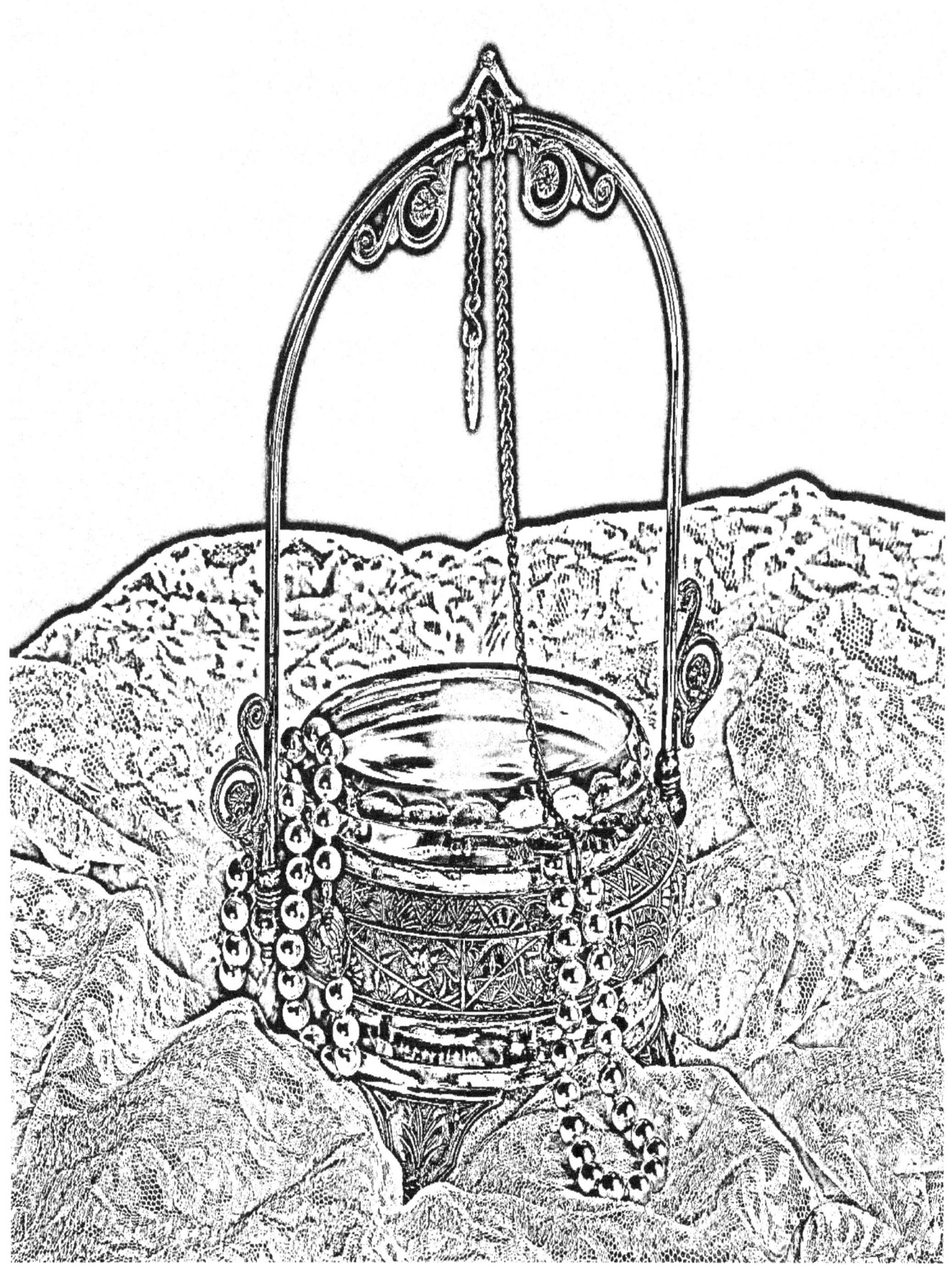

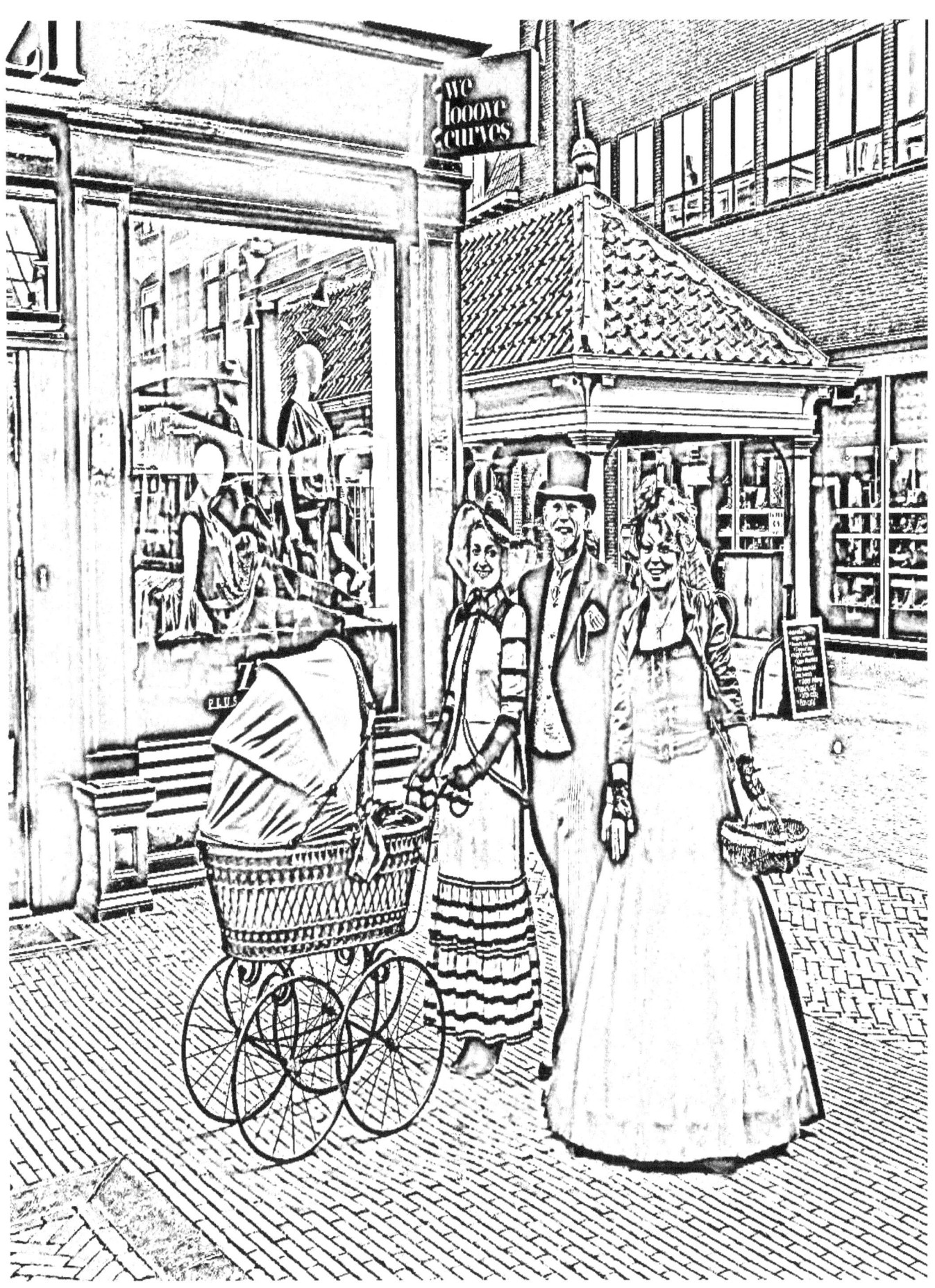

Thank You!
We hope you enjoyed our book.

Watch for more coloring books by ARN Arts LLC.
Visit us at http://arnarts.wixsite.com/books